Photo: Eli Williams

WK Litmag Staff: Mark Antony Rossi

Writing Knights Press Founder/Editor: Azriel Johnson

Volume 01—Issue 03:
Estimated July 2017

Want to join the team?
Email: waywardswordsubs@gmail.com
Subject Line:
 "Wayward Sword Team"

We need readers, additional formatters and a social media/promotion team

ISBN: 978-1-54549-077-8

The Wayward Sword: (Vol 01—Issue 01) Dangerous Submissions
Available: writingknights.com and/or writingknightspress.blogspot.com

It's a Wonderful Life, Brandon

Sergio Ortiz
Larry Fobes King "Leticia" January 13, 1993 – February 13, 2008

What's up, baby?
It was the step that haunted,
the cold predatory act, the final step,
the chards of the glass.

I filled the rooms of this school
with the scent of ghosts,
built the classroom out of Leticia's sighs,
colored the halls with Larry's anguish.

In school I wore a uniform
made from screams, like a window
between the cracks of air, or a leak
on its way down the steps of obsession.

"Baby," the blaze of going to bits,
of keeping guilt and loss at bay,
of two shots in the back of Leticia's head
the only solution.

The prosecuting attorney
walked through *una hojarasca*
on the way to her table. Her hair
full of dead, wet leaves. Hallway clatter
declared her ten pounds' thinner.
The jury, untangling Brandon
and Leticia: *What's up, baby?*
The defense begged jurors leave
their conscience in the hallway,
and it worked.

If you're murdered,
but you were transgender,
it always works.

YOU & ME (First Time)

Leslie M.P. Abramson

I imagined you in thirst & Hunger: Over and over again.
Tranquil kisses of love on a sandy, beach just you and me.
Time of innocence as we lay making love my nails entrenched into sun-soaked perfect skin.
I imagined you enthralled in ecstasy and us as one caressed by the wind knowing only one another and exploring wet warmth as only man and woman can.
United we shiver as the universe explodes in youth captured by secrets silently discovered.
Tongues gently cascade as time is consumed and I know there is no other.
Alone in my mind I am the little boy who quickly became a man.
I wake to stare at the beach as the sun is the moon in perfect glory.
We made this dream and I will never be alone again.
This is reality. This is us together.
Imagination consumed into tranquil kiss of forever.
We are encaptured never to be alone. The beach is timeless as I reminisce: there is only us,: just us...

Great American Slaughterhouse
Layla Lenhardt

You changed your name to kill a bloodline
and stretched my skin like the hide
of an animal from ocean to ocean
-the great american slaughterhouse.

I kept carving out my skull while you
watched with tolerant eyes and encouraging
hands. But in the dark, you forgot
about the girl with the hair: gold
like the tip of the mosques you've seen in photos
but never visited.

You were always searching for something,
To fill the American sized hole in your chest
but there was nothing but the lining
of a vagrants dream and my body at your disposal.

But childish games get old,
so you, tinman, brought
your gleaming axe down on my ribcage.
Shocks swam through me like swordfish
No one was there when the tree fell,
the silence was as thick as velvet.

Demitasse M.V.L.Narasamamba

Sometimes,
Neither the Sunrays
Nor your hunger wakes you up;
Only the aroma
Works on you magically;
When you are
Half awake and
Sip the lukewarm
Deep brown liquid, it just
Drips into your throat;
Ironically, not only the
Actual taste but also the
Aftertaste stimulates
All your senses;
Yet again, if you
Intently listen to
Your heart beat,
It says, please
Grab one more
Strong from the urn.

fishing late
the boat full
of one cricket

Darrell Lindsay

Contemporary French Philosophy
Alicia Cole

Bataille would approve of this poem.
Write 'cock' and 'slit' twenty times over;
explicate their fullness. They fit well
in a variety of parings. Try repetition.

He'd like how I measure the bubbles
that slurp when I'm defecating. They
leak from me, fluid and air. They're
always full, always round like existence.

If we can reach the infinite on le toilet,
we've accomplished something, now
haven't we? We've accomplished
something when fucking, after all.

Or just when breathing air. Whenever
there's a moment's pause, that's
when infinity sneaks in and stays.
Often for longer than expected.

Infinite puke. Infinite fuck. Infinite piss.
All together, even our horrible
moments-and, yes, a fuck can be horrible-
lick the edge of the eternal divine.

did you see those
semirigid hook scissors
at the disco

David S Pointer

Another day lost
Corner fetal position
Too many voices

Dean K. Miller

Mr Valery Petrovskiy

December, 31

On the late March snow, I walk about the town,
Or under a cold October rain on my birthday…
Sometimes, I roam along splashing April puddles,
Or it happens in January in hard frost,
Ever by myself…
Until, at the end of the year,
You recall me once.
Or I might just have made you up…
December, 31 is an odd date.

Layla Lenhardt

Cabo San Lucas

I don't remember if it was a race or how
many cups we had, but the mountain
was my personal jesus, splayed out across the skyline.

The taste of limes was stuck on my tongue
and the back of your hair, black from wetness,
had curled, ever so slightly, into a sleek little J
at the nape of your neck.

Sand is never as soft as it looks, but I don't think
I noticed its roughness on my feet as we ran.
The blue vastness looked almost drinkable as we got closer.
And finally, for the first time,
we slipped into the sea like a lost city.

should you decide
to paint a memory of me
while dreaming,
let it be like the glimmer
on an evening lake
 Darrell Lindsay

PW Covington

In Translation

She'd flick her ashes into
A Dr. Pepper can
Tell me she was
The survivor of a suicide pact
How she was raped, serving in the Navy
Jumped ship in Spain
And learned the language
Traveled for decades without visas
Fucking princes, painters, and heroin dealers

She took me to visit temples
Abandoned
Now that myth had overtaken religion
Happy Donut shops
Down the street from beat bookstores
Introduced me to men that knew men
That used to play piano in
North Beach Bars

That airport bar in Dallas
Outfield seats to see The Dead at Wrigley
Day drinking martinis on Frenchman Street
For lack of a better plan

Her poetry stands up to the turning of pages
But she understood
That she'd always be
Most appreciated

In translation

Blood drains down sewer
Violence settles nothing
Mother grieves again
Dean K. Miller

The Last Night

Karlo Sevilla

Lying on the mattress,
their backs turned against the other,
woman on right, man on left, in fetal position
and two feet apart, silence becomes the chasm
of a broken vow, while in the space
between them, lies supine,

their first baby,

"laughing with delight, the
day the music
died."

overhead table
high altitude incisions
after guests fall
David S. Pointer

ATTEMPT TO POETRY

PREM PALLAV

I sit to write a poem,
And I can't find a theme
Where do my emotions flow,
I search that tranquil stream.
All my memories I do recollect
A suitable one from them, I might select
Any powerful emotion if I do find
I might come up with some magical lines
After thinking for hours, exhausted by time
In a helpless state, myself I do find.

Then I skip this thought,
The emotional stream gave me drought
I try to change the notion
Now, I want an escape from my emotion
My poem is like a mission
Seems I need to learn tradition
Searching again for hours and hours
I do construct bookish towers
Ah! Writing a poem gives so much pain
All my efforts are going in vain

Meanwhile in the long hours
When I search the bookish towers
I come upon another variety
Who says poetry isn't beautiful unless it contributes to society
In the course of poetry's critical history
This was yet another unfolded mystery
The theory couldn't appeal to my brains
Hence, I was unable to compose any strains
I was feeling helpless and weak
Desperate, I encountered another Greek.

ATTEMPT TO POETRY (cont)

Where I progressed due to my fate
He said poetry expresses the truth ultimate
Unlike the historian who deals with the factual
The poet like philosopher solidifies the actual
After reading all that was left behind
When there was no stone left to grind
Still unable to develop a style
The tranquil mind was left volatile
One collected the emotions, other wanted escape
Between these learned pillars I was left desperate.
Finally, in the poet's school I do close my eyes
And then I start flying in the dreamy skies
After all these definitions,
Something is still left behind
As I do not follow any tradition
I do not know its kind
I'd just say a word, because I'm not so smart
All I've known till now is, poetry's just an art
All you need is a paper and a pen
Follow a sensible heart, not a learned brain...

Darrell Lindsay

our blue bag
of recyclables
placed curbside—
yet you would waste years of love
without sorting through much at all

BIRD FOOD

Ken Goldman

Left some bread crumbs in the yard for the sparrows.
And sure enough they lit there to eat.
First one, then four, then ten.
And as I watched, old Samuel, the neighbor's cat, happened by.
And he joined those sparrows, oh yes he did.
He grabbed the first, then another, and then a third.
Slapped 'em with his paw and one by one
Just stuffed 'em right into his mouth and chewed and chewed.
Oh, sure, the others managed to get away.
But I was still glad I had left enough crumbs there for them birds.
Since I'd promised old Mrs. Peters to feed her cat while she was away.

To A Love Muscle

Layla Lenhardt

You are the star to my moon,
the key to my lock,
a great oak tree under which I bask.
You are a gallant gentleman ready and willing
to jump
into the fray
And do what needs to be done.
I love watching you grow,
Vascular velveteen,
you enter.
You help me reach things I cannot,
your blood rushes, a silent crescendo.
And I love you still,
even on the nights you're afraid of the spotlight,
or the nights you drank too much
or the nights when you're just too tired
because in the morning,
I know I'll be graced by your caress.
You're the pitter patter of my heart,
Manly mahogany
Phallic ferocity
Sowing the seeds of life.

Mushroom cloud rises
Far away but visible
End certainly near
Dean K. Miller

I Took Another Mind-Ride Last Night

PW Covington

Black room dark with mirrors where I stood
With suddenly Asian features
Younger, full cheeked and erstwhile
I changed into a beautiful woman
Then a grotesque one, then an aboriginal child
Smiling

I saw myself from inside of the husk
Worn by a dying Nordic beast
Adrenal overload threw me to the ground
And I crawled closer to the mirror
Mirror with no edge or end
Placed my eye directly on the glass
I was seated on a bed in early winter

The full and solemn peace of high ordeal, satisfied
Came to me
The drug high of The Fear
That raged before was gone
I knew that somewhere near
An erotic cabaret was playing
I heard Ella Fitzgerald reading the poetry of Katie Hoerth
Kittens, lapping milk, could be sensed
Along with the barnyard calliope of commuter trains
Shrimp were being served on the flight deck

Axial tilt realizations
It was Girl Scout cookie season

"You don't have to be here when you die"
The voices told me in conspiracy
"Some of us haven't checked back in for years."

winding road at dusk
the logger slows down
* for a deer*

Darrell Lindsay

Paying Reparations to India
Alicia Cole

I believe I made you tea, if not
bathed you. It was a dream.
I really should have bathed
you. You really should have
worn the white shirt buttoned
over your brown skin, and khaki
shorts. You'd have them. They
were nice. I blew you on the edge
of the terrace, your hands firm;
they softened when I let you hit
me in the bedroom, my mouth
the sharp blood red of bleeding.
Your hands stayed insistent.
Your hands opened in prayer.

Auditorium Shores

PW Covington

The thought floats into my mind
Like the Colorado River
That this wouldn't be a terrible
Day
Or way
To die

Maybe the voices would say
"He was found sitting against a tree
 at Auditorium Shores
A book of Charles Bukowski poetry
 open beside him
Authorities confirm the presence of
 recreational drugs in his system"

And, then
Like a sudden under-tow
Grey as early spring over-cast
I hear the voice conclude
 and it turns terrible

"The official cause of death
Was a self-inflicted gunshot to the head."

Man, I gotta stop smoking while reading Bukowski by myself
in early March.

haunted woods typer
custom obits
while you bleed out
David S Pointer

DRUNKEN EPIPHANIES (I)

Eli Williams

Life is a colony of fireflies
encased in a mason jar
that you forgot to
poke holes in.

You were
worth it

You wouldn't know it
if you never really looked
at her like I do.
Not everyone walks around
and takes pictures of flowers
digital snapshots
of vivid memories.
She changes with the seasons
Seems to flow with the breeze
She's an apathetic queen
Driven by misery she's only seen.
She won't let anyone in
It must be too damp
Or corroded
Or too cramped for her style
She's used to being used
And sadness is just another word
Alone is not a description

It's just an existence.
It's not my fault you don't
feel the love I give
You don't have to do this alone
And you never have
But you get what you give.
I have watched you walk away
Too many times to care
about the broken bones from
holding yourself too tight.
You survived and keep surviving
And all you care about is survival
I care about caring
Hugging ghostly corpses
And trying to find you in crowded bars
looking at the backs of heads in dim light
I'm starting to choke on the thick puffs
I'm starting to think none of this

Was ever worth it.

When We Were Young

Layla Lenhardt

I remember you, sucking lemons. You were carved from bone, I was 23. You were always dreaming of pretty things while I was looking for salvation in anything I could hold between my calloused hands. That was before you lived out of suitcases and pushed lies out of the gap in your front teeth. That was before we pressed ourselves into other people. That was before the birth of the American-sized hole in my chest. Back then we flew kites that snapped white in the audacious autumn air. I tried keeping you at arm's length but your bourbon eyes refused. You were the wind ripping at the roots of my hair.

When you ignore me
It sucks lifeblood from my heart
Vampires go thirsty *Dean K. Miller*

My Fishy Romance

Karlo Sevilla

Weeks before she flew away like a flying fish,
I've noticed her laughter change
and become like sardines, canned:
belted out to the tuna of those heard
in talk shows and sitcoms.

Still, she was a once in a lifetime
mackerel in my life, an angelfish.
She was my best lover, barracuda none.
I still remember her and sing salmons
of praise and gratitude.

I can not goby-ond the thought of her,
but I have to let go of her:
Our last month together was spent
herring hurtful words from her.
She was carp-ing at every little thing I did,
and I felt eel every time she stabbed me
with her swordfish.

Now I'll always be waryfish and koi
at love; never again should I feel words
that are like a piranha or shark
shoved up my corydoras aeneus.*

*Scientific name of bronze catfish.

skin flap seizure
field mastectomy
with a dull rake

David S Pointer

Reprise
Layla Lenhardt

You leaped through my window like a stray
tabby cat and we'd sit up late, drinkin' Victory.

For a long time, I spent my life counting miles
between rest stops. I swore I'd find the answers
folded between the hills of eastern PA or in tangles
of black hair, or even in the blackberrying pain
I unearthed that summer.

I told two different narratives and the words spilled
 from both sides of my mouth while your forehead
creased with a painful sharpness.
It was then that I learned
that same days just aren't yours.

But we never broke eye contact
while the story dissolved in our minds like
a sugar cube in coffee,
furling and unfolding.

After the incident it took me so long
to become a person again.
I rebuilt myself with pieces of you.

WE DON'T KNOW WHY
Eli Williams

As long as I don't breathe I won't see you.
Sometimes, love isn't enough
And we don't know why
But everything happens for a reason
And even if that's not the case
We have to believe it

It's the only thing we can believe
When the loneliness sets in

And you can't drink anymore
Because your world is blurred

And your breathing is shallowed
And the walls start moving
And you close your eyes
And the tears they burn
And the nails dig deeper
And you clench your jaw
And your noises muffle
And you sleep

But you never want to
Because you always wake up.

nut sac masks
Halloween monsters
tear own designs

David S Pointer

Madman's sanity
"Kill them all! Kill them all!" "No,
Just the ones I hate" Dean K. Miller

Shooting in Realistic Environments

Sergio Ortiz
Larry Fobes King "Leticia"
January 13, 1993 – February 13, 2008

Children with torches and crosses,
sleepwalkers looking for their mother
beyond the shadow.

Women searching for their children
scattered in the blood river; offspring
fragments of a letter of despair.

Those that were going to die
saw her proceed
without recognizing her child
in the crowd. She bid the kids
farewell with her hand

and hummed until she sank
into the horizon.

217 Poetic Points (excerpts)

Scott Thomas Outlar

Poetry is the mouthwash in your cereal at 4:48 a.m.

Poetry dropped its cargo in your backyard. Go excavate and seek the core.

Poetry lies so sweetly, and stabs with precision.

Poetry likes to peek behind your curtains, dig through your drawers, and expose all your secrets.

Poetry saw the future, decided it was too hot to handle, and so wrapped it up in layers of digestible mythos.

Poetry plays kiss-kiss with fires, and massages pollution out of the system.

Poetry wants its ink back, time looped, and energy propelled forward.

Poetry has five aces up fifteen sleeves with fifty other ways to cheat.

Poetry whispered carnal karmic vibrations into the huff-and-puff chamber of your heart; the lungs, like a train, kept steady.

Poetry is pure all the way to the caramel center.

Poetry laughs at the thought, then perishes it.

Poetry is a political bomb, a psychological war, a primal roar for restoration.

217 Poetic Points (excerpts) (cont.)

Poetry is that idea of yours, this idea of mine, another idea from over yonder, and the fact that we can all exist in the same sentence structure without blowing each other to Kingdom Come.

Poetry is bark ripped from the tree, chewed up with twelve fangs, and spit back to the soil.

Poetry believes that you are most likely wrong, but can probably figure out a means of interpretation that allows you enough wiggle room to squeak by with the illusion of being right once in a while.

Poetry is a popinjay singing, in or out of tune, having a great time either way (the wind blows).

Poetry is a revelation perched on the tip of your tongue.

Poetry saw the sun in a new light, and there began bulbs bursting in its brain like clockwork.

Poetry is kaleidoscopic in nature, splashed with waves of neon florescence, operating through the use of wavelengths that can't quite pierce the veil of worldly dimension and form.

Poetry is a tight black dress, high heels, soft jazz, five lit candles, three bottles of wine, and a full weekend still to commence come morning.

Poetry sighed when you nibbled on its ear.

Poetry likes the way you lick your lips when there is magic pulsing in your eyes.

Poetry is like a drunk at the bar; there's always time for one more round (and round the lines go).

Poetry is the game we play when the bell rings.

Poetry opened its eyes before the dust did; took a breath before the garden grew.

Physics

Christopher Hivner

When grandpa got sick
I was only four.
My memories of him
are pages torn from
a picture book
pressed to my mind
with now rusty push pins:
me sitting on his lap,
grandpa with a cigar,
eating zebra cookies,
looking pale and tired
in his hospital bed,
and that's it,
four images
burned into my memory.
All the rest
of our time together
is gone,
lost in the quantum foam,
floating in the past,
out of my reach.
I can stretch,
search my thoughts
with imaginary tentacles,
I can cry out
to God or the universe,
whoever is listening,
and make my plea
but grandpa is still gone
before I got
to know him.
Einstein said that
time travel
is theoretically possible
but theory
doesn't put me
back in grandpa's lap.
Time travel
is an illusion,
but my memories,
few as they are,
are real.

**2016 Pushcart Nominee
from Writing Knights Press**

Found in:
"When Science Collapses"

Packaging Tape

Jonathan Thorn

Ripping packaging tape
Seers screeching
In my mind
As if stretches
Against flat brown
flaps
Encasing
Relics
Of a closing
Chapter.

These artifacts
Of this journey.
Relished memories
Of pain and joy
Confined
And
Sealed
By tape.

Now, these sit
As Pandora's box
Gathering dust waiting
For that packaging tape
To screech
As it
Withdrawals
From those flaps,
Releasing
A flood
Of memories
Into my
World
Again.

**2016 Pushcart
Nominee from
Writing Knights Press**

**Found in:
"Sophistimicated"**

IN FRONT OF THE CLINIC DOOR

Peggy Schimmelman

Found in: "Crazytown"

2016 Pushcart Nominee from Writing Knights Press

Hey there, sign-toting, pro-life people.
I appreciate the leaflets and the scripture referrals
but let's get real about the prospects
of this Zika-infested fetus —a parting gift
from my mother's own salacious, rapist lover.

Who will volunteer to parent this child?
Not you? Nor you? Still you bar the door
screaming, pleading. I'm missing the point.
Life starts at conception. Abortion is murder.
You point to your Bible:
I'm a sinner. A killer. But hey—

I'm a good Southern Baptist, dipped in the river
washed in the blood, steeped in Sunday sermons
prayer meetings, church camp, Bible School
and old-time tent revivals.
Don't tell me what Jesus would do.

You believe that this fetus, torn from my womb
would fly to the arms of the Savior, and yet
you'd assign it instead, to an earthly existence,
helpless, deformed, a life at the mercy
of a damaged child-mother, clueless and broke
her future flushed away with the placenta.

Judgment Day? I'll take my chances.
But what if God asks, at the pearly gates
why you thought it okay to shred my life and
condemn this child to a miserable fate
instead of sending it home to Jesus?

How will you answer that, pro-life people?
Here's an idea:
maybe you should read your favorite book
instead of waving it around
like a pistol.

HER DEATH
Allen Berry

In the early aftermath,
her death became a cell
and I, a monk,
recording her life in
gradual deliberate script,
by the light of a candle.

In time her death
became a holy relic
a charm around my neck
that I would hold out
to ward off the darkness,
proof of her once existing.

Now her death is a portrait
hanging over the mantelpiece
of my life. Ever present, yet
unremarked upon, until a passing
guest pauses before it,
ponders, and asks its story.

2016 Pushcart Nominee **Found in:**
from Writing Knights Press **"Sitting Up With the Dead"**

Hands

James Schwartz

Dad is fond of telling me,
When I was a babe,
He held me in his palm,
His hands were large,
Rough and calloused,
By a life of labor,
My own small hand,
Stops growing,
As I grow older,
My fingers curling,
Into claws,
I don't notice,
Until school,
Bombarded with questions,
I don't know answers to,
I learn to wear long sleeves,
Even in summer,
Tucking my malformation,
Into my pocket,
Before bounding outdoors.
I am taken to Specialists,
To a Rosicrucian-esque healer,
Who places eggs on coals,
Murmuring gently,
Hypnotizing me.
I am taken to Shriners,
Where I see a small boy,
With a hand larger than my fathers,
I stare in his beautiful eyes.

**2016 Pushcart Nominee
from Writing Knights Press**

**Found in:
"Secular, Satirical
& Sacred Meditations"**

Appetites

Bethany W. Pope

In dreams, I run in the body of a fox; a male
with a thick red bush and a hungry mouth.
My teeth are sharp. Your bones are pale,
rabbit; so white in all that red. Your feet touch your little
 fluff-tail
as you twitch in the snow, struggling to claw your torn
 body south.
In dreams, I run in the body of a fox; a male,
ripe with strength and rank with stalesmelling
hormones. I'm following your path.
My teeth are sharp, your bones are pale,
but you're not afraid. You're a bitch, here; beautiful and hale,
and you've got steaming, fragrant genitals to taunt me with.
In dreams, I run in the body of a fox; a male:
I mount you while we sleep. Our bodies thrash and flail
until one takes the other in their mouth.
My teeth are sharp, your bones are pale.
We come to swift agreement. Love leaves a trail
for us to follow. It leads from mind, through flesh, to truth.
In dreams, I run in the body of a fox; a male.
My teeth are sharp. Your bones are pale.

**2016 Pushcart Nominee
from Writing Knights Press**

**Found in:
"Don't Try Me: Fragments
and Flesh-masks"**

QUINTESSENCE AND OTHER DREAMS
Ken Goldman

She hid from Death but he found her
cowering inside her youth.
And when he came he took her aside
and whispered,
"So how was it, your life?"
And she told him,
"I'll let you know when I am done.
I have not yet flown like a firefly,
Nor kissed a handsome prince.
And I would enjoy a walk along the Seine."
They argued for a handful of her dreams.
But in the end he took them all.

Author Bios

Peggy Schimmelman is the author of the novel Whippoorwills and the novella One Day You're a Diamond. Her work has appeared in WinningWriters.com, Aleola, PacificReview, Comstock Review, Kind of a Hurricane Press, 100wordstories.org and others. She is currently working on a second novella and a collection of flash fiction. (PG 26)

Allen Berry is a poet, teacher, environmentalist, and avid fan of Jazz and Film Noir. He is a 2013 Ph.D. graduate of the Center for Writers at the University of Southern Mississippi and the author of: Travel for Agoraphobics and Distractions and Illusions. Prior to attending USM, he received a Master of Arts in English Literature from the University of Alabama in Huntsville. In 2001 he founded the Limestone Dust Poetry Festival and served as the president of the Board of Directors until 2006. He currently lives, works, writes, and hikes in Huntsville, AL, his adopted hometown. This is his third collection of poetry. (PG 27)

Jonathan Thorn is a stay at home dad, working at a grocery store, and living in Columbus, Ohio with his wife and five children. He has always loved writing. For him, poetry is an outlet that allows expression of his vision of the world. (PG 25)

Author Bios

James Schwartz's poetry has been published by various poetry journals including Poetry 24, Politiku, @7x20, Babel: The Multilingual Multicultural Online Journal, The New Verse News, Nostrovia! Poetry, piecejournal and Silver Birch Press blog.

His book, The Literary Party: Growing Up Gay and Amish in America, was published by inGroup Press in 2011 and poetry in Among the Leaves: Queer Male Poets on the Midwestern Experience (2012), Milk and Honey Siren eBook (2013), The Squire: Page-A-Day Poetry Anthology 2015, Writing Knights Press 2014 Anthology, QDA: A Queer Disability Anthology (2015) and Alpine Suite (2013), Poetry 4 Food 2 (2013), Poetry 4 Food 3 (2014), Arrival and Departure (2014) chapbooks and FourPlays.

Most recently, essays by Schwartz have appeared in RFD Magazine, The Good Men Project, Best of Books by the Bed 2 anthology (2014) and a short story in Jonathan: A Journal of Queer Male Fiction (2014). He resides in Michigan. (PG 28)

Christopher Hivner writes from a small town in Pennsylvania surrounded by books and the echoes of music.

Website: *www.chrishivner.com*, Facebook: *Christopher Hivner - Author*, Twitter: *@Your_screams* (PG 24)

Bethany W. Pope is a recently naturalized citizen of the United Kingdom. She is author of numerous short and long collections including "The Gospel of Flies" through Writing Knights Press. (PG 29)

Author Bios

Karlo Sevilla of Quezon City, Philippines does volunteer work for the Bukluran ng Manggagawang Pilipino (Solidarity of Filipino Workers). (PG 9, 18)

David S. Pointer lives in Murfreesboro, TN with his daughter and cats. (PG 6, 9, 16, 18, 20)

PREM PALLAV is a graduate and an aspiring writer. (PG 10)

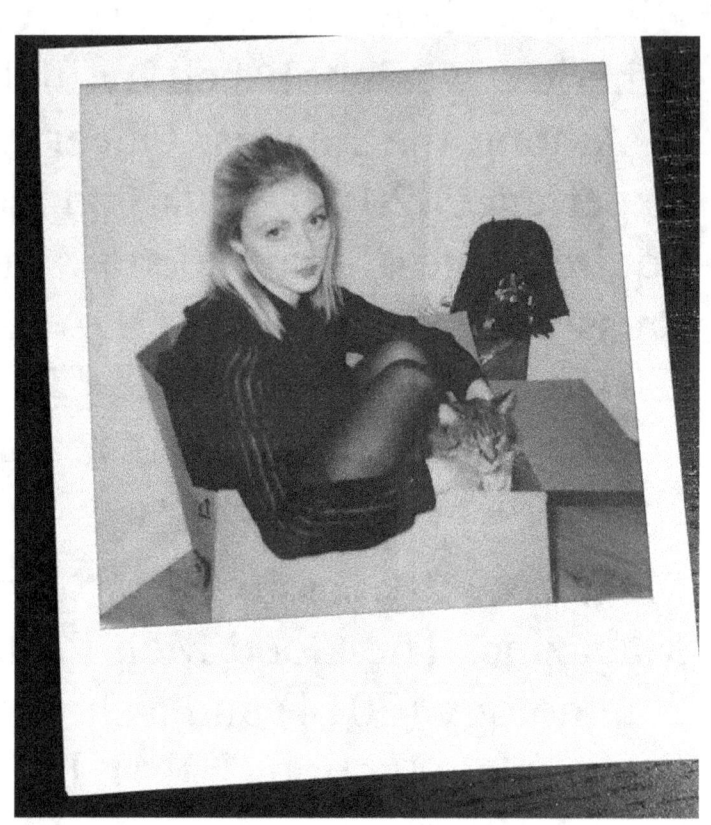

Layla Lenhardt had once gotten drunk at Jane Austen's house and has since been published in The Wooden Tooth Review, Right Hand Pointing, Third Wednesday, and was Poet of the Week on Poetry Super Highway. She is the founder of 1932 Quarterly. (PG 3, 7, 13, 18, 19)

Author Bios

Ken Goldman, former Philadelphia teacher of English and Film Studies, is an affiliate member of the Horror Writers Association. He has homes on the Main Line in Pennsylvania and at the Jersey shore. His stories have appeared in over 840 independent press publications in the U.S., Canada, the UK, and Australia with over thirty due for publication in 2017. Since 1993 Ken's tales have received seven honorable mentions in The Year's Best Fantasy & Horror. He has written five books : three anthologies of short stories, YOU HAD ME AT ARRGH!! (Sam's Dot Publishers), DONNY DOESN'T LIVE HERE ANYMORE (A/A Productions) and STAR-CROSSED (Vampires 2); and a novella, DESIREE, (Damnation Books). His first novel OF A FEATHER (Horrific Tales Publishing) was released in January 2014. SINKHOLE, his second novel, has been accepted by Bloodbound Books and will be published late summer 2017. (PG 12, 30)

Alicia Cole is a writer and visual artist in Huntsville, AL. (PG 5, 15)

Mr Valery Petrovskiy, an international writer from Russia. (PG 6)

Author Bios

Contributors w/o Bios:
Dean K. Miller (PG 6, 9, 13, 18, 20)
Eli Williams (PG Title Page, 17, 20)
Sergio Ortiz (PG 1, 21)
Leslie M.P. Abramson (PG 2)
M.V.L.Narasamamba (PG 4)
Scott Thomas Outlar (PG 22)
Justin Jackley (Cover Image)

PW Covington's work is inspired by the North American highway. He is a Pushcart nominee, and lives in rural Texas. www.PWCovington.com (PG 8, 14, 16)

Edge Of The Pond, Selected haiku and tanka by Darrell Lindsey, was recently published by Popcorn Press. It is available on Amazon.com, amazon.co.uk, and from the publisher at www.popcornpress.com . It contains many of his short form poems that have won international awards (Japan, Croatia, Bulgaria, Canada, Romania and Poland). One of his poems is included in Haiku In English: The First Hundred Years (W.W. Norton, August 26, 2013), which has an introduction by Billy Collins. Lindsey has also been nominated for a Pushcart Prize (2007) and a Rhysling Award (2014), and won the 2012 Science Fiction Poetry Association Contest (Long Form category). (PG 4, 7, 11, 14)

www.ingramcontent.com/pod-product-compliance
Lightning Source LLC
Chambersburg PA
CBHW081313180526
45170CB00007B/2682